To order additional copies of this book, contact:
Xlibris
844-714-8691
www.Xlibris.com
Orders@Xlibris.com

ISBN: Softcover 978-1-4134-5513-7

Print information available on the last page

Rev. date: 05/19/2021

Are Your Ears

On Straight Today?

Written By
Hershell C. Hanley

Illustrated By
Emily J. Brammer

This work, with its library poem, is offered as a tribute to libraries, especially the Adams County Public Library System, and to the libraries worldwide, all with their blandishments for research, for art, for learning, for communication, for the social graces and better living.

CONTENTS

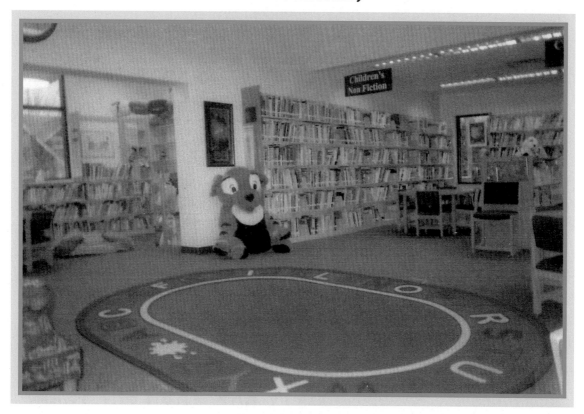

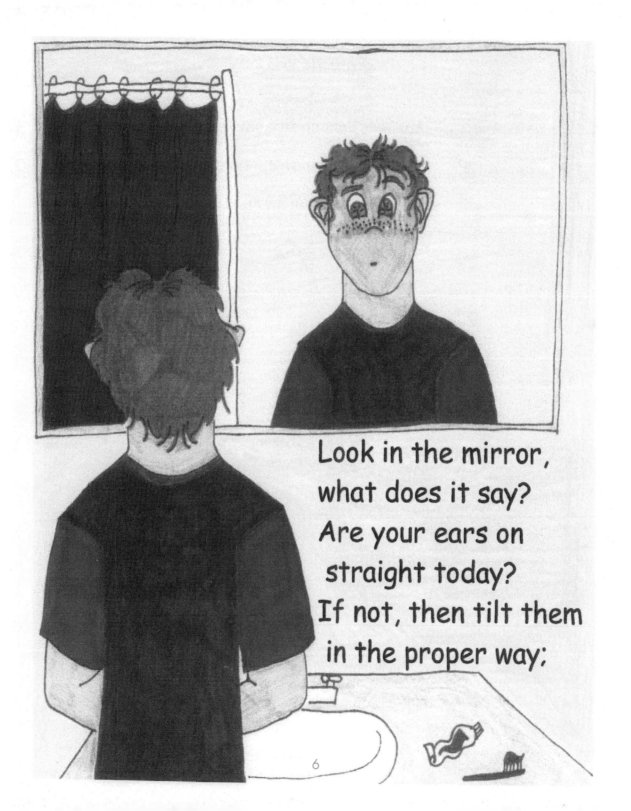

Look in the mirror,
what does it say?
Are your ears on
straight today?
If not, then tilt them
in the proper way;

6

But most ears are curved, the nurses say,
And they're very pretty that way,
To catch the sound and make it stay.

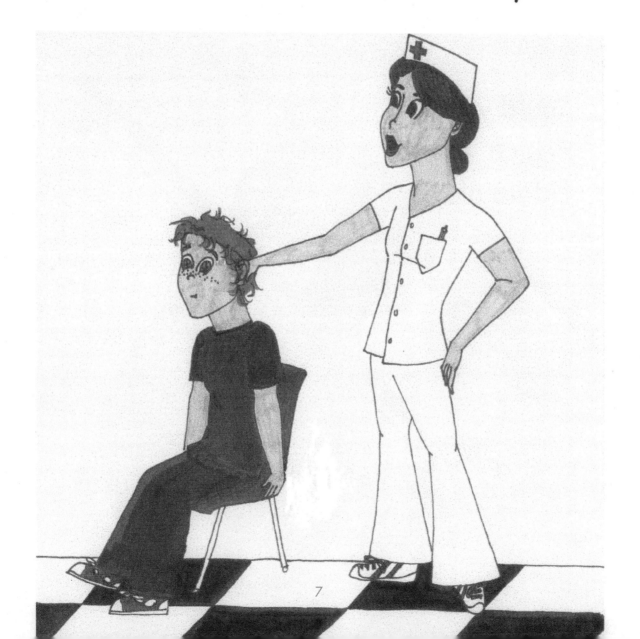

Can you hear
what people
say?

Could you
hear a
fiddle play?

8

Can you hear a donkey bray?

His ears are big and tall, aren't they?

But sometimes they flop in every way,

And then, they're not even straight--

SAY
STRAIGHT
Way
Today

Now how did
that rhyme get
in play?

In all that
<u>say</u>, and <u>way</u>,
today?

I'm marking out that
hee-haw bray
I'm trying to write in
rhyme without a bray,

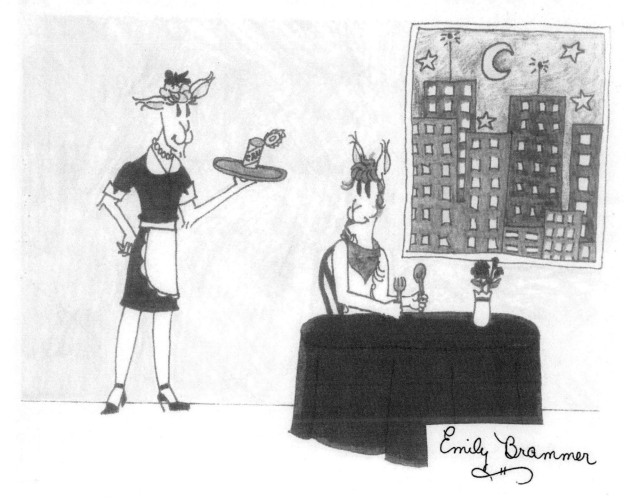

I thought of writing of a
goat with a green toupee'
That's French, not the goat,
 but the hair display
But he just eats cans
and anything else in his way;

Better, I'll write about a rondolet,

That's a song with lines of
syllables that number eight,

Now there's that pesky rhyme again
 to ruin the day,
Which that goat caused me to say,

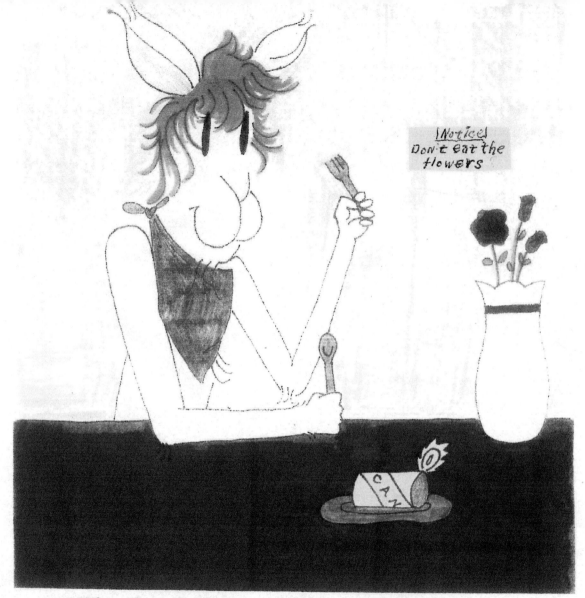

That's what he did to the can-
spelled capital A-T-E, ate ——
That rhymes with straight and
number eight,

So I give it up and call it all a day;
Certainly I'm not eating cans-
No way!

And let that goat eat hay!

Children's Day

At the Library

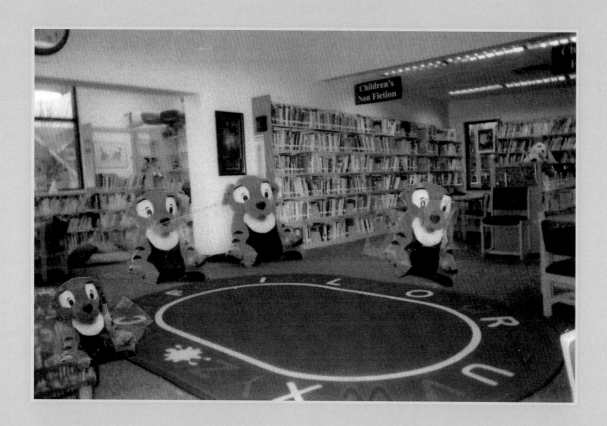

Children's Day at the Library
yesterday, the snowflakes fell,
And we made angels in the snow,
And then came in to play;
And if it rains today,
Then could we go to the Library
and stay?

You'd like it there without your
timer bell;
We'd read the books with
words we know so well;

We'd look at the art on page display
With all the colors - pink and
green and gray,
And read what counselors have
to say
About our study and our play;
The books are quiet in their
usual way,

Unless you choose the ones with
voices recorded in that soft
and pleasant way;
Even librarians learn to speak
that way.

Or we could punch the keys,
And run the mouse,
All in some edifying way,
To reveal the living story
of any place or day;
or beat the super-hero game;

-- or you could write a poem,
if you want to have your say,
For someone else to read
some other rainy day.

May we go?

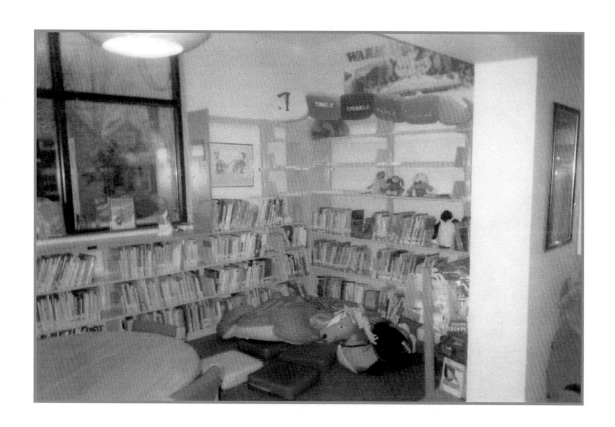

Yes! We may!

Concerning the poem, "A Children's Day at the Library,"
which was inspired by the following:
Several times I have pulled up in my car outside the library,
when a van or station wagon (or several) would drive up
alongside.

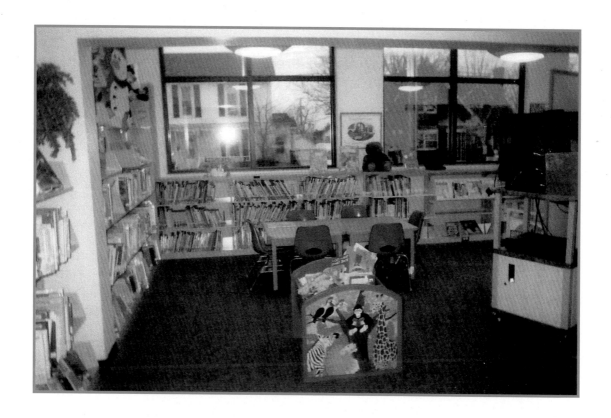

The mother would go around, slide the door open, reach in and unbuckle someone inside, and out would come 3 or 4 (or more) children, all jumping, running and yelling in play around the vehicle. One could wonder how it would be inside -- but -- it was very different -- very quiet with all interested in their books or recordings -- or computers.

I could add a line or two to the poem:
"The children danced in loud display,
But once inside the library,
Both books and children were quiet, as a mouse-
All the livelong day.

Mousie says: "Draw a face for whited-out person
on p. 20 -- or a cap with town or school initials."

Don't Run Away

Don't run away;
Just stay and play,
And in this way,
Make this a mother's
happy day;
And watch out the
window, like yesterday,
Where now the snow-
flakes play,
And cover up a giant
bale of hay;

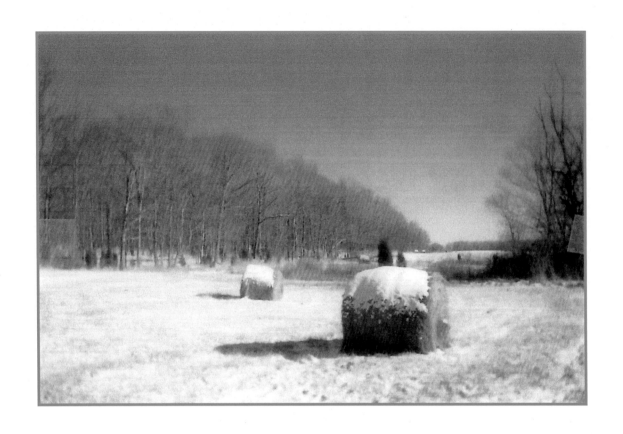

What will the cows now
say?
Will they blow their
horns all day?
That is, if they had horns
that would blow;

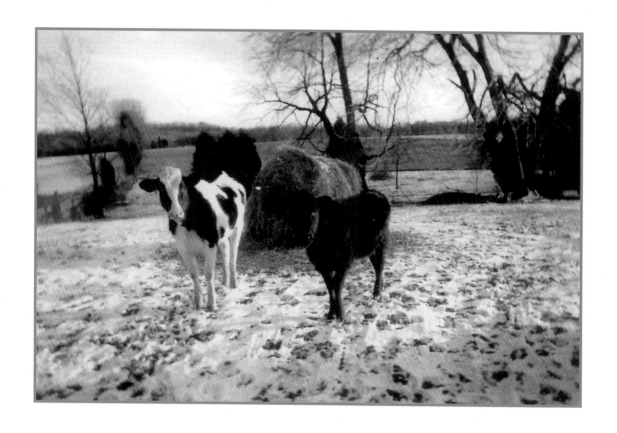

Which brings us to
another rhyme to
know;

Can you guess the rhyme?
It's no,
Spelled in a different
way --
Oops! That's what I
didn't mean to say, --

Like n-o, no, don't
go away --
Don't go!
Just stay and play,
Like yesterday,
Hay, Hay!

Reader's quiz:

1. How many bears are in the book? _____ □

2. How many cows are in the book? _____ □

3. How many bales of hay are in the book? _____ □

4. How many ears are in the book? _____ □

5. What is a rondolet? _____ □

6. How many strings does the fiddle in the book have? ____ □

7. How many books in the library? (Ask the librarian.) ____ □ □ □ □

Printed in the United States
by Baker & Taylor Publisher Services